INSTRUCTIONS FOR THE APOCALYPSE

Instructions for the Apocalypse
© Tim Williams and Rod Sweet
www.instructionsapocalypse.com

Design consultant: Doriane Laithier
Editing: Buzz Poole

The authors would like to thank Lliwen Williams, Kathy West,
John Williams, Neil Coombs, Matthew Horgan, Bedwyr Williams
and Iolo Williams

Library of Congress Control Number: 2008940209

Printed and bound in China through Asia Pacific Offset

10 9 8 7 6 5 4 3 2 1 First Edition

This edition © 2009
Mark Batty Publisher, LLC
36 West 37th Street, Suite 409
New York, NY 10018, USA.
Email: info@MarkBattyPublisher.com

www.markbattypublisher.com

ISBN: 978-0-9817805-8-0

Distributed outside North America by:

Thames & Hudson Ltd.
181A High Holborn
London WC1V 7QX
United Kingdon

Tel: 00 44 20 7845 5000
Fax: 00 44 20 7845 5055

www.thameshudson.co.uk

CEFNOGI CREADIGRWYDD
CYNGOR CELFYDDYDAU CYMRU
THE ARTS COUNCIL OF WALES
SUPPORTING CREATIVITY

Supported by the Arts Council of Wales

INSTRUCTIONS FOR THE APOCALYPSE

Words by Rod Sweet
Illustrated by Tim Williams

Mark Batty Publisher
New York

*"Now. I've thought about this.
You're going to need a religion."*
Gareth Gray

For Jan

From: Julian Clowes
Subject: **get a load**
Date: 24 October 2008 14:10:00 GMT-07:00
To: stephen.currie@ucwm.ac.uk
▶ 📎 1 Attachment, 386 KB (Save ▾) (Slideshow)

Steve,
Look what I found. It's not him is it?
Jules

Kind regards
Julian Clowes
Marketing Executive
Library Informations Services
University College of West Mercia
Tel: +44 1265 323 154

From: Stephen Currie
Subject: **RE: get a load**
Date: 24 October 2008 14:24:20 GMT-07:00
To: julian.clowes@ucwm.ac.uk

Hi Julian,
Indeed it is. I would guess late 1960s, certainly before UCLA.
Steve

From: Julian Clowes
Subject: **RE: re: get a load**
Date: 24 October 2008 14:52:38 GMT-07:00
To: stephen.currie@ucwm.ac.uk

Bloody hell. "The Picture of Gareth Gray"...

Kind regards
Julian Clowes
Marketing Executive
Library Informations Services
University College of West Mercia
Tel: +44 1265 323 154

From: Stephen Currie
Subject: **Re: re: re: get a load**
Date: 24 October 2008 15:01:36 GMT-07:00
To: julian.clowes@ucwm.ac.uk

Ha ha

Eco-prof's daughte to halt "cynical" e>

BY MARIA SEARGANT

A ROW has broken out over an "extraordinary" collection of photographs, audio tapes and other documents left to the University College of West Mercia by the late wife of Gareth Gray, the firebrand professor and author who committed suicide two years ago.

His wife Mona bequeathed the collection to the university library before her death in October, but now their daughter, Sandra Krejpcio, for some years a resident of Palm Desert, California, insists the collection was left to her and is seeking a court injunction to stop the university holding an exhibition next month which, she claims, is intended to "denigrate" the late Prof Gray.

"The university basically couldn't handle my father," she told *The Mercury-Sentinel*. "They wanted him out. Now that he can't defend himself they're trying to denigrate what he stood for. It's totally cynical."

She added: "I'm sure my mother made an honest mistake but new information has come to light in the form of letters and other correspondence that make it clear the photographs and other effects were intended for me. I'm just asking the university to respect that."

The photographs include many taken by Prof Gray's industrialist grandfather Emrys. This is believed to be a rare collection depicting day to day life of the emergent middle class at the turn of the last century. It is not known what the audio recordings contain but Prof Stephen Currie, head of the geography department and a former colleague of Gray's, said: "They offer an extraordinary insight into the mind of one of the most original thinkers this country has seen in the last 40 or 50 years."

After reciving a PhD from the School of Architecture and Urban Planning at the University of California in Los Angeles, Gray returned to England in 1983, taking up the post of lecturer in land economy at UCWM. 1987 saw the publication of his book *They Made You a Moron: Travels in a Fascist Regime*, which popularised modern anarchist writers and condemned what Gray saw as the state's incursion into every aspect of private life.

He criticised his own discipline, even his own colleagues, for propping up what he saw as repressive social and economic patterns. He was a popular lecturer, however, securing star status in 1992 when he was imprisoned for trespassing in the protests over the Twyford Down motorway extension.

He was also subject to a sensational disciplinary hearing in 1994 over allegations of sexual misconduct after two female students alleged he propositioned them repeatedly. Although the panel failed to conclude he had broken the university's code of conduct, he lost the support of key faculty superiors and resigned in 1995.

His departure sparked protests

ries
bition

among some students, who demanded the university reinstate him. His final years were spent in seclusion at his home in north Wales. He was to prove as colourful a character in death as he was in life, committing suicide in 2007 by ingesting a fatal dose of highly toxic alkalides extracted from yellow jasmine, or gelsemium, a poisonous plant.

Ms Krejpcio said she has seen a draft of the exhibition catalogue, though she would not say how.

She accused the university of trying to tarnish Gray's reputation with a view to stopping the raucous "Gray Day" rally students hold every year on May 2 to mark his death.

A former student of Gray's who is now on the library staff, Julian Clowes is curating the collection. He denied it was meant to belittle Gray's reputation.

"There was some interpretation that went into putting the catalogue together, certainly, but it was in no way meant as a disservice to Gareth," Mr Clowes said. "In the last decade I spent more time with Sandra's father than she did so I think I'd know what he'd have wanted. It's a celebration."

An application for the injunction will be heard at Birmingham Magistrates Court next Wednesday.

A spokesman for the university confirmed that the date of the exhibition was under review. He added that the university was sympathetic to Ms Krejpcio's request and was seeking legal advice.

INSTRUCTIONS

All right. Ten years. I'd say you've. I'd be certainly very surprised if. I mean ten years and you'd be lucky.

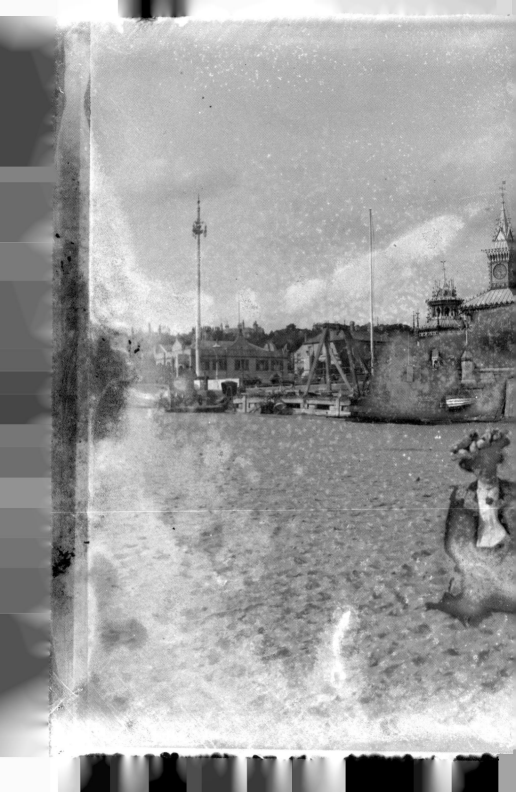

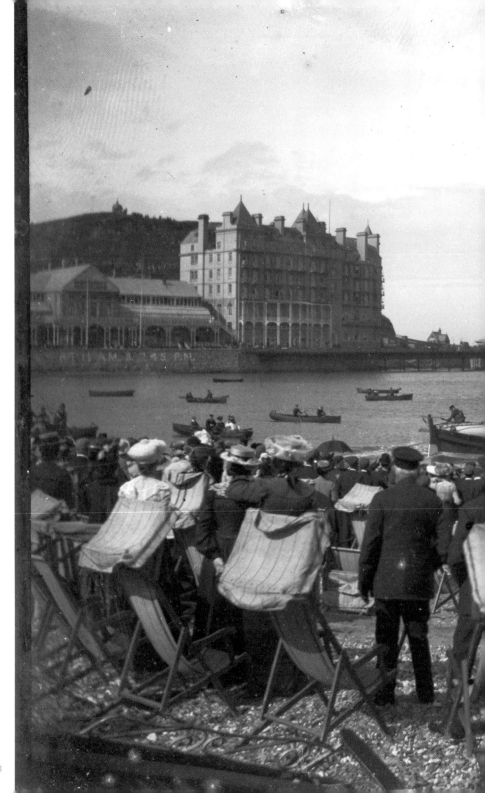

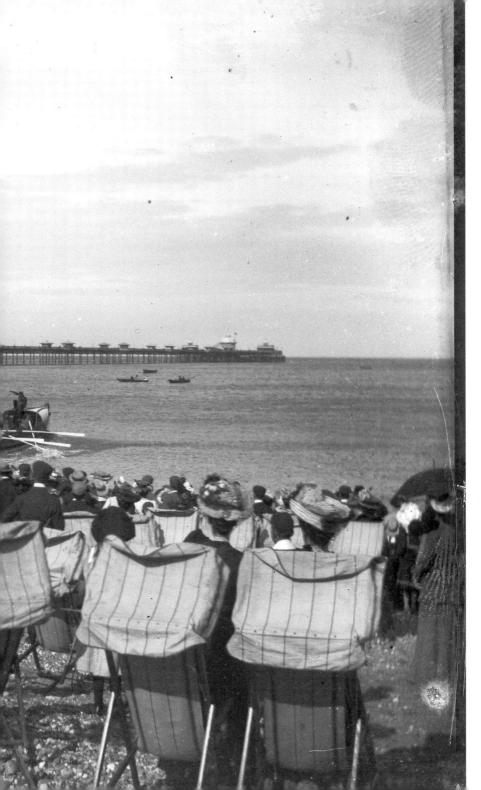

You've got to open your eyes, Sandra. It makes me sound crazy but I'm going to say it anyway. The signs are all around. They must be obvious even way out there in your hippie hideout. Do you think you'll be able to go on fulfilling your interesting potential forever? Do you think anyone's going to buy your tooled leather belts or whatever it is you make out there when housewives are defending their tins of sardines with shotguns? When they're coming after you for your tin of sardines? When the mob outside your house is getting restless because there's a rumour going around you've got a tap that works? I am so very, very sorry.
[STOP]

1. War will start to get in the way of global commerce. There will be wars over resources, probably oil in the first instance. But civilizational fault-line wars will also heat up, drawing America deeper into multiple conflict theatres. Unrest among populations will increase as failing economies and the effects of climate change cause mass migrations. The business of governments, even in the countries that used to be rich, will be making war. Not just on other countries but on their own people.

2. Choose a location that is hidden and easy to defend. Your best defence will be obscurity. Avoid places where passersby are likely to come upon you by chance, or where you can be watched from a main thoroughfare. Consider natural obstacles like water and mountains. A narrow valley or coastal headland may work, but don't trap yourself. Make sure the land is varied enough to support you, with water and a mix of pasture, wooded and arable land. Build dwellings underground to blend in with the landscape. In almost all cases build dwellings underground.

3. Go about your business quietly before the dissolution. Don't let anybody know what you're up to. Everyone in the community must practise secrecy. Casual observers shouldn't be able to tell how many live with you. Your lieutenants can go out to do things but train them to blend in. Train them to not stick out.

Listen. You know a civilization's running out of steam when you've got irrationality everywhere. I'm talking craziness. When you've got class conflict, imperialist wars, a fixation with intoxicants. I sound like John the Baptist, don't I? I don't care. Imperialist wars. Irrationality. You've got the wildfire spread of extreme religion. Nearly a quarter of Americans describe themselves as fundamentalist Christians. They call themselves that! These are people who think God created the universe six thousand years ago. Forty percent of the vote for George Bush in 2004 came from this lot. You know, you could say, What's irrationality? One man's unreason is another man's blah blah blah, I know, but we're talking here about actively shutting down to common sense. Faith is believing something you know isn't true. What can you say about Iraq other than that it was a really dumb way of trying to get what we needed? The institutionalization of the instrument of expansion. In other words, doing things that are dumb. And sexual perversion. Sex expressed as a perversion. Any suggestions? How about this. People spend, well, shall we assume it's blokes? Blokes in the West, let's say. Blokes in the West spend twenty billion dollars a year on internet child pornography. Okay? Twenty billion a year. This is the business to be in! Six times bigger than online music sales. It's almost as much as Americans spend on milk. Class conflict. Do you get class conflict anymore? No. Yes. Well. What you get is a situation where a nineteen-year-old lad who by all accounts was an accomplished drug dealer at the age of fourteen gets on the

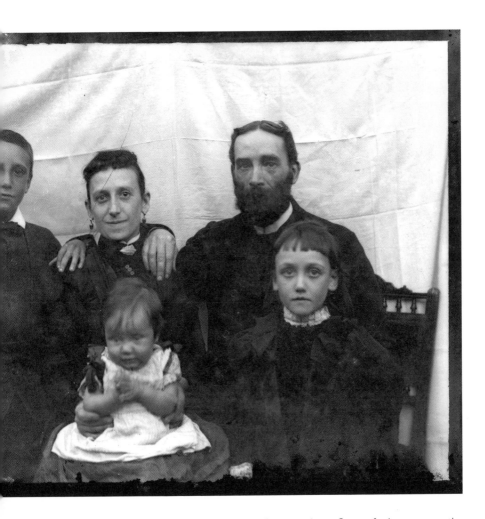

Piccadilly line and blows it up and twenty-six other people with him. Because of Islam. What is that? What do you call that? Okay. There've always been people who don't participate in the authorized pastimes, but. It's an adolescent cast of mind. I'm not in the club so I'm gonna take it out. They're children, but it doesn't make them any less deadly. You can't cut off their pocket money and send them to their rooms. We don't have class conflict, we have a generation of assassins. One of them was the fourth child of a factory chargehand. The mother and father tried very hard. Don't get me wrong. The mother is a translator in the hospital. Upstanding people. He's a Pakistani teenager in Leeds. Finds Islam at seventeen. The interesting kind of Islam. Now this. Now this is religion. He blows up a bus. With him on it. You know what's going on here? It's not even actually anybody's fault. It's the shutdown gene.

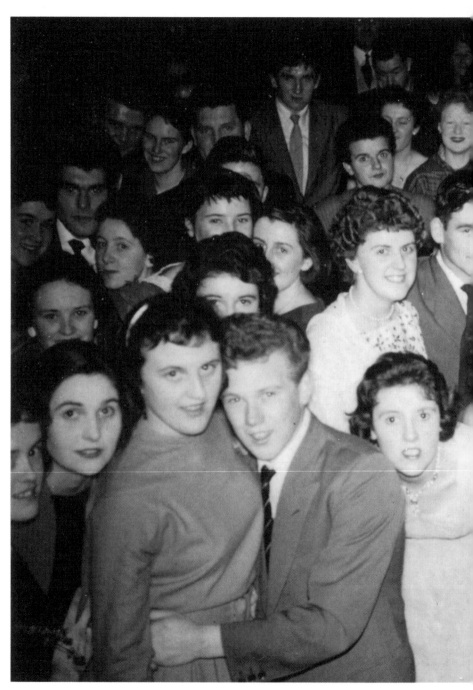

Freshers Ball, 1963, Bangor University, where Gareth Gray studied history before taking an MA at LSE.

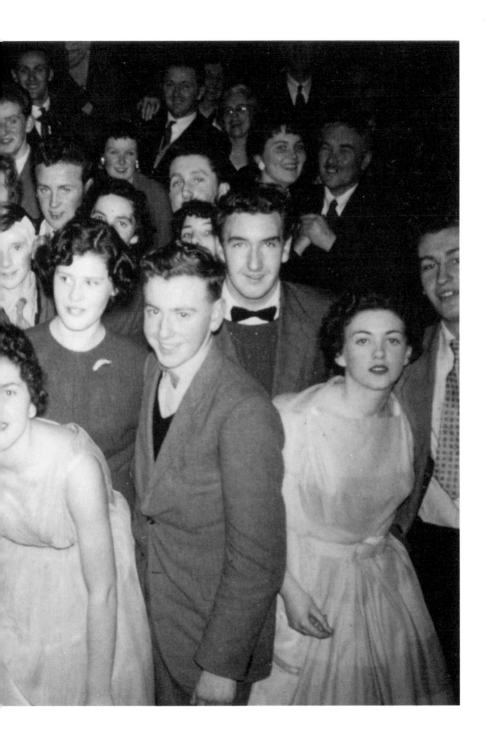

The civilization gets to a certain point where it flowers and then starts to die and it triggers the shutdown gene. In the young people. I think this is key. If this civilization was in any kind of fighting shape, these kids wouldn't be able to do this. It's not like we haven't handled this kind of thing before. It's amazing how a few public executions focus the mind. Gibbets...
[SOUND OF KNOCKING
VOICE GARBLED.]
Go ahead! What? Ha! The number's nine-nine-nine, Mona. NINE-NINE-NINE! Good lord. It's been hard on your mother. I'm blind now, by the way. That's why I'm dictating this. I should have taken the stuff for the glaucoma. It cuts down the pressure of the ocular fluid, but what they don't tell you is it cuts your pulse by forty percent. I was lolling around like a limp rag. Then the panic attacks. "Social anxiety disorder" is the term. The loss of the ability to tolerate spatial separations from a secure base. I think my definition is better. The acute awareness that the place you live in is a shit hole. Anyway, we're almost finished here. Listen. The money I'm leaving is not a lot. I'll tell you how much I think there is. I think there's seven hundred and twelve or seven hundred and twenty thousand or something like that once you've sold the stock and the Neston holdings. George Creighton will sort it out for you. I've instructed him in detail and he's pretty good. Sorry to land you with all this but I'm sure you can handle it. Just talk to George and stay on top of him. He's pretty good but you need to stay on top of him. Seven hundred and change. That's what we're looking at. All that's left of Grays Paints and Dyestuffs. Filtered through me to you. Untouched, I might add.

4. Take pains to understand
 technology before the dissolution,
 especially weapons, surveillance
 and transport. It will be hard to
 predict who will have established
 reserves, and the capability to use
 them, in order to take advantage
 of fluid circumstances to establish
 a footing. It will be crucial not
 to underestimate the reach and
 potency of adverse interests,
 especially in the early days.

5. Many will try and ride around on wheels like they did before and that'll be their
 undoing. You must go on foot, at night. Even bicycles will attract attention.

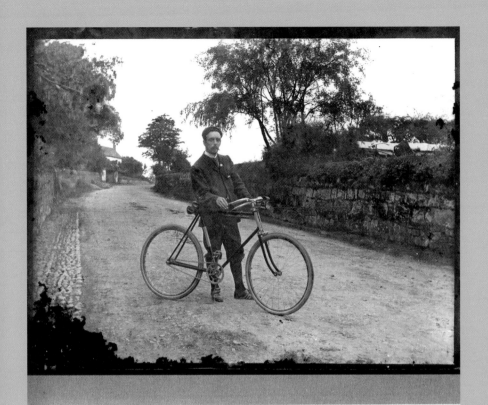

I neither added nor subtracted. It wasn't my fault. In under two generations how do you get from a turnover in today's terms of half a billion a year to a sum that would not buy you a detached house inside the M25? Old Emrys would turn in his grave. He'd be really hacked off. Imagine what it was like for him when he took these pictures. Summer, 1902. The maid hands him his Times she's just ironed so he can check his stocks while he eats his kipper. The gypsum mines in Nova Scotia. The tea plantations in Ceylon. The sun was always in the sky somewhere over the British Empire. The second GPD plant bedding down nicely in Deeside. He's prospering but not so busy yet he can't take his new wife on an eight-week tour of the British Isles by steamer and his own private rail car. He's itching to try out the new-fangled photographic gear. Takes up a whole crate. He's feeling like a little kid. What a laugh! These guys had arrived. They had underwater telegraph cables from Gibraltar east to Singapore and from Sydney Australia across the Pacific to Esquimault on Vancouver Island. They had a navy bigger than the next two biggest countries combined. If they want to carve up mining concessions in China who's going to stop them? It was super. There was no conceivable way this would not carry on forever. Not like these days. You say "lovely morning" and you both think, Christ, yes, it is lovely. For November. It gives you the creeps. Why exactly is it so nice? They didn't have thoughts like that. In 1902 Britain had more warships than France and Germany combined. And Japan. What was there to worry about? He was thirty-two. Sixteen years later twenty-three million young men would be dead including his two younger brothers. That's something there. Jesus. Talk about experts. You know they had machine guns in 1914? I mean, they had machine guns in 1865, but in 1914 they were really quite effective. But in Sandhurst you learned that you win battles by hammering them with cannon. Then you send in the infantry guys with bayonets. Bayonets being the descendent of the pike, mind. Then you send in cavalry guys with swords. That is the way you win. The cavalry is especially important. It worked for Napoleon and it will work for you. Clausewitz said so. Anything else is codswallup. Sure, we've got machine guns. Got to move with the times. But that is not the way you win. Oh yes, and always keep a straight front line. These guys were the experts. Haig. Pershing. Cavalrymen, of course. And they went on throwing ton after ton of horse meat and man meat against machine guns. Emrys was spared. By then he was too old. But his brother John was killed at Verdun and his brother William in the Somme. Meatbags. Both lieutenants.

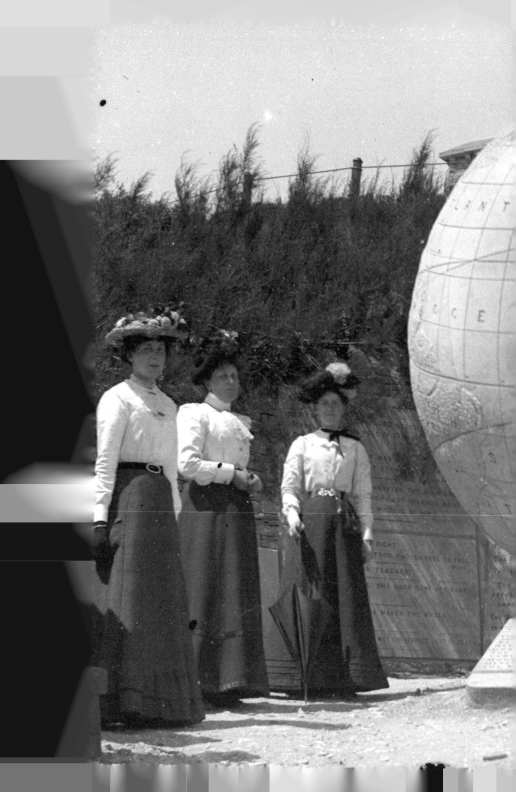

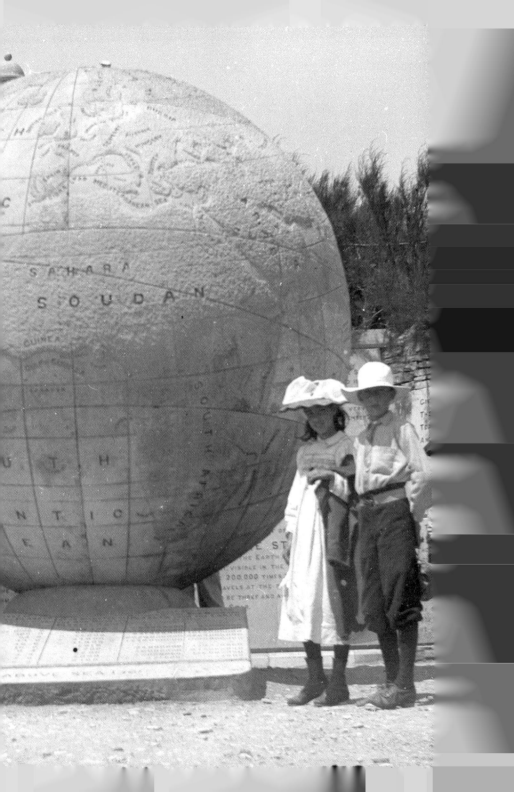

Emrys was also too important because GPD was supplying paint to the navy. Paint. I mean, golly. The stuff you have to think about if you're going to war! They lost that contract to ICI in the thirties and that was just about it for GPD. If it wasn't for the ah, the rectitude and the general, I don't know, bustle of your grandfather, another John, most of it sterile I might add, you'd've probably never seen a penny of it. So we have him to thank. He collected non-executive directorships the way most of us collected albums. Anyway. Seven hundred and twenty thousand should be plenty for what you need to do. All I can say is you'd better get busy. I'm not going to get drawn into how much time you've got. That would just be giving you something to nitpick over. All right. Ten years. I'd say you've. I'd be certainly very surprised if. I mean ten years and you'd be lucky. That's probably a big overestimation. We're in the golden years. We think that if we can just stop global warming and invent electric cars all this'll go on forever. Tooled leather belts. No democracy has ever gone to war against another. Remember that? And we're not going to start now. When you think that you know the end is close. Golden years. A civilization is finished when it doesn't believe its own ideology anymore. At least it's dead in America, and America is our core state. Optimism. Progress. Inventiveness. Coming up with better ways of doing things. I bet you didn't know we even had an ideology. We do. We did. But it's dead now. The American instrument of expansion, which is now just a hysterical plutocracy, has basically gone into advanced mental necrosis. All it takes is one word. One word. Hippie. San

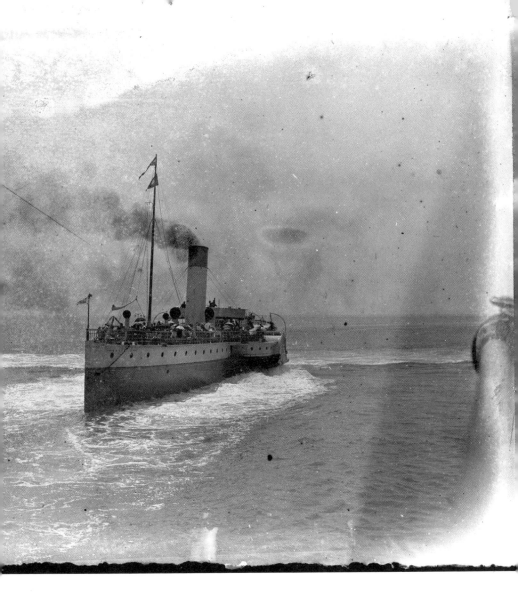

Francisco. Endangered. One word, and whole congregations start snickering. Whole towns. You'd think good old American know-how would be coming up with nifty little cars that run on air. They invented airplanes, didn't they? They invented telephones! Americans have always meant business. American coal production went up something stupid like eight hundred percent between 1865 and 1900. The amount of railway track laid down went up six hundred percent. The amount of refined sugar went up by a gazillion percent. What's wrong with these people now? What are they doing? [STOP]

6. Remove yourself from official records and databases. These may fall into the hands of malign interests looking to exert control over the population, such as it may be at the time.

7. It may be that multiple power bases emerge as resource nodes detach from central control. Police and branches of the military are obvious candidates. Because they'll have guns. But think laterally. Oil companies, telecommunications suppliers, hospitals and even supermarkets will all be in control of scarce resources. For a while, anyway.

8. Keep track of how the
 local power landscape
 is shifting beyond
 your territory. Never
 get involved in any
 alliances, but always
 understand the
 landscape.

Do you know what really sells books in America right now? The second coming. Of Jesus. The Rapture. Jesus coming down and calling the faithful to join him up in heaven. All the faithful living and dead, and kids under eleven. Bodily. Up they go. You're going to have fetuses bursting out of unbelieving pregnant women. You're going to have donated livers, because it's the whole body, all of it, you're going to have livers bursting out of relapsed alcoholics. It's going to be chaos. Then for seven years the Antichrist is going to rule the world through the UN jointly with the Pope. Then Jesus comes back as a field commander and there's going to be an almighty great battle. Jesus with cartridge belts crossed over his chest. That's Armageddon. It's all foretold in the Bible. The Book of Revelation. Okay? The best-selling adult fiction series ever is all about this. You won't see it on the New York Times best-seller list because they don't count Christian books. Why, I don't know. But this series has sold sixty-three million copies. The reverend Tim Lahaye. They eat this stuff up. There's no point dealing with Iran, the king of Persia, because the Bible says it's going to join up with Gog, that's Russia, and wipe out Israel. God is going to prevent this, though. It's all foretold. Using America he's going to destroy all but one sixth of that army. He's going to wup their asses. These people gobble this stuff up. The politicians don't believe it. At least I don't think they do. One hopes! But it is ever so convenient to have a population that likes the idea of being able to zap bad guys from space and who don't like ay-rabs or ruskies or pakis or chinky-chonks. [STOP]

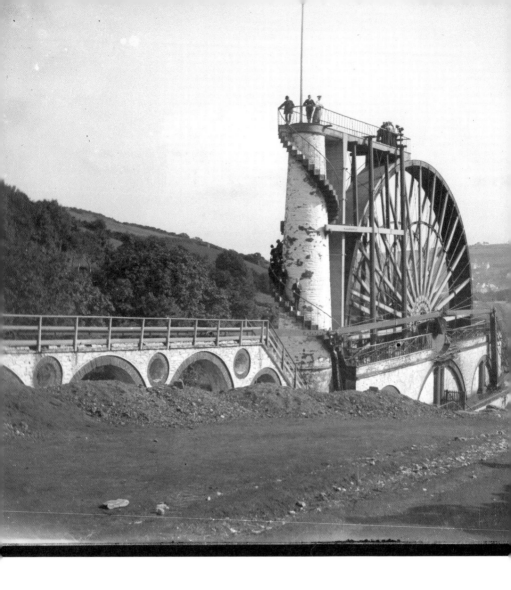

When a civilization does not believe its own ideology anymore the game is up. And lo, there will be craziness in the land. Pentecostalism is growing by nineteen million a year. America's national debt stands at nine trillion dollars. It's uh. Is that a lot? America's debt is sixty percent of its gross domestic product. It was only thirty percent in the eighties. Yes, it's a lot. It's uh.
[STOP]
And they can't win wars anymore. They say they've won and then years later they're still fighting. This is our core state.
[STOP]

9. Don't invite people you like to join you. Grow your own. Healthy, good breeders.

10. No families. Children are raised communally. The right to reproduce is allocated by you. Families always work against effective central control.

11. One dwelling, or dwelling complex, for you and your lieutenants. In there you have your own chamber where the library is. Keep it under guard. One for females and children. One for males. Underground dwellings for animals, too. A bunch of cows strolling around is going to be a dead giveaway. You must not have a husband.

12. It may seem like a good idea to select your lieutenants now and prepare them for life after the cataclysm but you should resist this temptation for company. There is a real danger they'll lose their bearings and then they won't be any use to you. Groom the people you need.

13. You're going to need people who know how to make shoes. You're going to need people who know how to make rope. You're going to need people who know how to kill quickly and quietly. And you will have to train them.

I did not sleep with my students. We need to get that straight. There was no sustained programme of sexual exploitation. This was just straight character assassination. Newspapers. Gareth Gray has resigned his post. It was revealed today. This paper can reveal today that Gareth Gray, blah blah blah, sustained programme of exploitation, blah blah blah. Court records show he was arrested for possession of marijuana in 1992. Most of his neighbours also believe Professor Gareth Gray is a scoundrel. In a poll conducted by this newspaper a full eighty percent of respondents said they agreed or agreed strongly that Gareth Gray should resign. Most agreed strongly. Very strongly. Only a few said they just agreed. It appears also that Gareth Gray has a history of poor performance in athletics. The disciplinary hearing continues today.
[STOP]

Gareth Gray, aged 5, with family in Liverpool, 1946.

Final year students, geography department, UCWM, 1987.

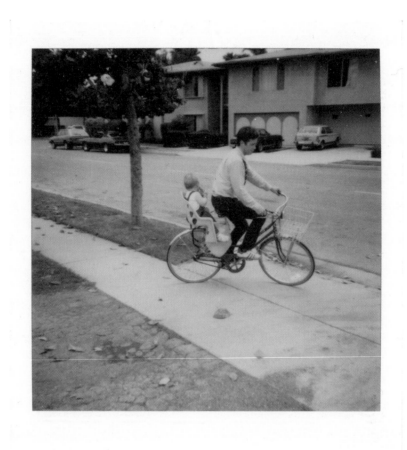

You're thirty now. And four months. And sixteen days. You vowed never to set foot in this house as long as I lived. I know you can do this. I'll tell you what you are.

I can do that now without getting it in the neck. You've got this awful need. You've always been. You're a ring leader. You tear out these big chunks and it's never enough. Why did you disown me? Those are your words. I don't think you can disown your father by the way. I don't believe. Though I could disown you. That'll piss you off. For the first year or so after you disappeared I spent a lot of time cataloguing my sins against you. They were not very serious, I have to say. Once I forgot your birthday. Another time I gave you the same thing as I did the year before. Your birthdays were tense times for your mother and me. There was this awful need you had for. I don't know what.

[STOP]

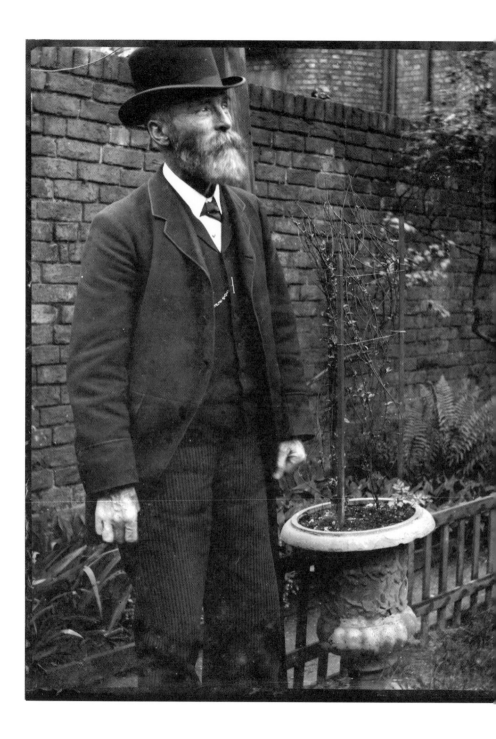

Let's get a little perspective, shall we? Do I seem very old to you? My life is over. You think you'll be around forever but your life is already half over. Think about your great-grandfather Emrys. That was ever such a long time ago, wasn't it? 100 years. Life was all black and white, like the pictures. Now think about his great-grandfather. He doesn't even have a name, does he? That was an endless, wearisome amount of time ago, wasn't it? No, it wasn't. He did have a name. It was Ivor. He was a stocking merchant in Llanrwst. He made a fair bit of money and he married three times. Yes. They had sex in those days. Steam trains were around. There were cowboys in America. America was around. Okay, let's go back farther. We'll stop messing about. The Dawn of Western Civilization. Think about the year 871. Imagine a year called 871! I wonder if they said "I don't know why but I keep thinking it's 872"? 871! An impossible amount of time ago, right? Not really. A little over a thousand years. A thousand years! Think of it! And that's just the beginning. Two thousand years ago the Romans were in full swing. Five thousand years before that, we're skipping loads here, but five thousand years before that the Sumerians were living in cities and writing things down. They had haircuts! Are you impressed? Wait. Nine hundred thousand years ago. Nine hundred thousand. We could round it off to a million, but nine hundred thousand is good. Nine hundred thousand years ago, people were walking around, doing stuff. There were Homo Sapiens, like us, and also Neanderthals. Both were human. Neanderthals might even have been cleverer actually, judging by their tools. They didn't look so hot. Their heads were connected to the front of the top vertebra, not the top of it. They didn't have much in the way of foreheads or chins. You get the picture. But still, Homo Sapiens and Neanderthals came across each other, and mated. They had children. You can imagine the scene. Homo Sapiens, lady, foraging for macadamia nuts, taking a bit of a breather from camp life. Out of a clearing comes Mr Neanderthal, heading north, following the glaciers and the mastodon. Well hello there, handsome! This happened! It shouldn't matter. All those lives stacked up like that. Mine's over. What do I care? Why do I want you to do this? I want you to prevail. I picture grandchildren.
[STOP]

14. You'll need a
managed influx
of new people
because the effects
of inbreeding start
showing up in the
first generation.
Somebody's going to
have to keep track. It's
impossible to tell what
the situation will call
for but your options
will range from
targeted recruiting to
capturing breeders.

15. If you have a husband everybody will want one.

PILOT SWITCH

CLUTCH TAKEUP SWITCH

PILOT LIGHT

TERM STRIP

TERM. BOX

EXCITING LAMP

LAMP RES.

YELLOW
BLUE
WHITE

12
11
10
9
8
7

GREEN
BLACK
RED

SHIELD

PROJECTOR MOTOR

5 MFD COND. 9983

BLACK GREEN
RED WHITE
YELLOW

RED
BLUE
GREEN
BLACK

VOLT-M

420 OHM RES. 9137

100 OHM 02036

FILTER 02194

LINE SWITCH
SELECTOR SWITCH

BELL & HOWELL CO.
CHICAGO U.S.A.

FILMOSOUND
DESIGN 130
MODEL C&D

SERVICE DATA

DRAWN
APVD.
6-29-36

SUPERSEDES MOD A&B

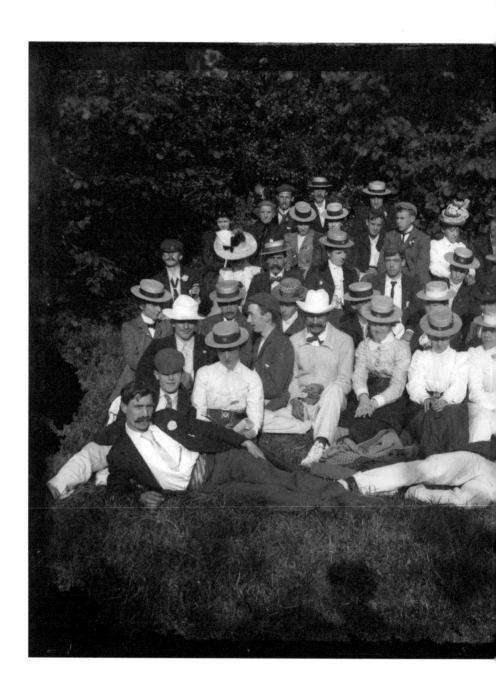

I used to have ambition. I used to think that the point of life was to have some kind of ambition. Making progress on a variety of fronts. You work for your family's security. You work for their well-being. Over generations you prune away the tendencies that don't get you anywhere. It's about ambition. It's like a lava lamp. Some bits going up, some bits going down. Except on the whole there's progress. A net reduction in human suffering. More proper people around. I don't feel that anymore. I have to say, it's kind of a relief to be done with all the hand-wringing. I suppose we had a go. Here's my big ambition now. That you see your 39th birthday.

[STOP]

16. Buy lots of guns and ammunition. Train yourselves how to use and maintain them. Practise regularly in an underground range so the noise doesn't draw attention. Practise when it's windy. Train yourselves how to make and use longbows for when the bullets run out.

19 A longbow has an effective minimum range of 200 yards. Made out of the trunk of a yew it's way better than a wood-steel composite crossbow. That's about 60 yards. Obviously, you've got to hide bodies.

17. Sentinels have got to be watching for strangers. You'll need some kind of signal system. Mirrors or maybe flags. The question has always got to be, Why is somebody coming? People are going to kill you if one, they know you're there, two, they think you've got something they want and three, they think they've got a chance of taking it from you. The last thing you need is reports getting back to some marauding expansionist. Have they got a radio? Have they got a phone? You just won't know.

18. With strangers who come into your midst, find out what they know. Be tuned in to their uses before killing them.

20. Your three immediate preoccupations should be food security, territorial security and the internalization of controls among your people. The last is certainly the most important of all.

21. Speed up the withering away of any vestigial literacy, except for yourself and your lieutenants.

Now. I've thought about this. You're going to need a religion. That will come in very handy. That's where the pictures come in. You can't expect people to just bumble along growing food. You need something to soak up their mental capacity. You're going to need a religion. Right. The ancestors. The sacrifices they made for all these incredible refinements. Their purity of vision, blah blah blah. Come on, think it up! How about this. Once every two years it's the big ceremony. The tribe can pass through the chamber and gaze upon the faces of the blessed ancestors and receive their blessings. The ancestors reach through the pictures with their energy and retune your souls because the ancestors really want your tribe to get it together and journey through the present trials and meet them at the other side and share in the blessedness etcetera because the ancestors live in a realm beyond time, etcetera. They may be ancestors, but they also inhabit a parallel universe in which time does not exist. Oh bollocks. You know. Think it up! I kind of wish I could be around to have a go.
[STOP]

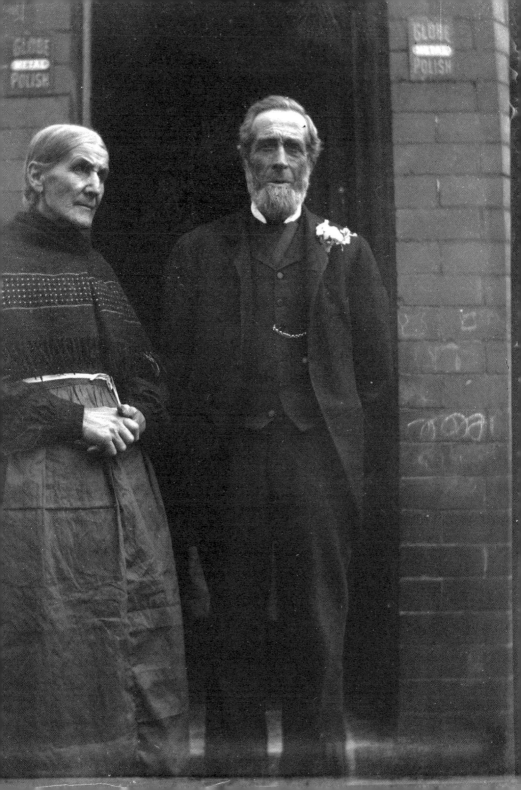

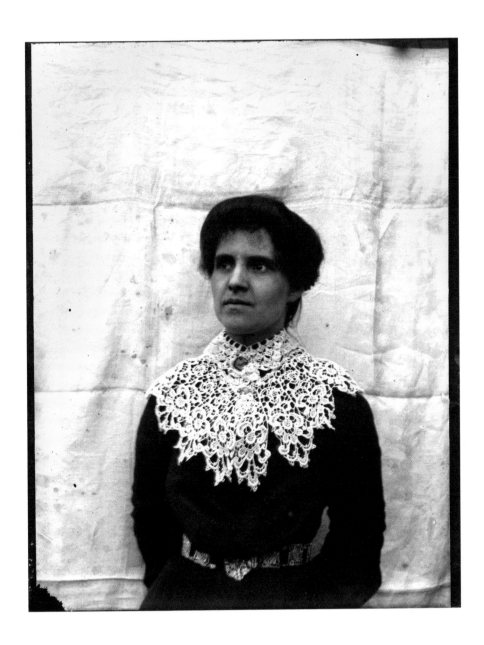

The people you want are the girls shrieking outside the corner shop in August and by spring they're pushing a pram. The lads. Revving and strutting. These are the ones you want. Nothing in their heads to dismantle. Muscle and bone. Urges. Habits. How you actually get them is something you're going to have to figure out. Maybe you set yourself up as a foster carer or something. Get them dependent on you. It's their children you want. There are a few things you can do. Look at Jim Jones. Strip away references to the outside world. Ban literacy. Let them watch television. No. Wait. Big Brother. Oh my. Oh dear, oh dear. What an idea. What's Big Brother? Big Brother is footage of a time when people could talk directly to the ancestors! See? You can hear it! These people, the contestants, were like Greek heroes, half gods and half humans, who got up to all sorts and the gods would come off Olympus and get involved. But the people pissed the ancestors off with their endless bickering and petitions so the ancestors withdrew and then came the cataclysm and now the ancestors are waiting for your tribe to reach the right level of spiritual and technical readiness so they can come back and help you take over the world. You could have ceremonies where you watch Big Brother and then explain what it means. Might be hard if you don't have electricity. The ancestors were trying to teach moderation, community, obedience, self-control, harmony, problem-solving, consideration, tolerance, you know, listening skills and all that. To ah, to a decaying civilization. The first recruits won't go for that but like I said it's their children you want, and you can teach them anything you like once the parents are out the way. But on the other hand it could be helpful if the parents set a tone. A kind of reverence you can build on. The first ones will be there on their own volition and while you can erode that sensibility you can't ever be sure. Look how many made it out of Jonestown. Quite a few. You get people leaving and blabbing and you're going to have visitors. You don't want visitors. The second generation will be yours. You can bet on that. Do you doubt you can do this? Listen to me. Look at what he did. This yokel from Indiana. Jones was amazing. Amazing! Amazing! In 1956 he was a little student preacher. Standing up in front of Bible-believing folk. He had a twist though. You'll need a twist. The ancestors. His big thing was racial unity. He adopted a Korean kid and a black kid. He had a rainbow family. For another thing, he was the best healer anyone had ever seen. He'd zap some woman, send her off to the loo and she'd come back claiming she'd just passed, you know, this thing. A cancer. She'd hold up a pig's liver or something and the crowd would go nuts. Jones would get his people to go through people's bins so he could get information about them to prove he was psychic. It was electrifying. By 1971 he was calling himself God. He was kicking a Bible around up on stage and daring God to strike him down for it. He was wearing white polo-neck jumpers and red satin robes. He was pointing out the men and the women, from the pulpit I mean, he'd had sex with. In church! These god-fearing people ate it up! By 1978 they were queuing up for his juice.
[STOP]

22. Groom a coterie of strong-arms loyal to you only. This is your guardian class. Devise ways of ensuring their total identification as enforcers of your will and your successors' will. Train them to have the same spirit as dogs. In other words, devotion toward their own and anger toward strangers. Maybe grant them sexual privileges. With you. This is the only class permitted to reproduce.

23. Make sure at least one of these is killed in some kind of battle at least every 18 months, even if you have to orchestrate it. Use death liberally in the beginning. You can expect a period of trial and error. Have no compunctions. There will be two types of people, those who are helps and those who are hindrances. Nothing else.

24. With your lieutenants you can challenge each other on your judgements but only when the critical moment has passed and only when there's nobody around to witness it.

25. You are just going to have to be very uncompromising with the sick and the old. And the uncooperative.

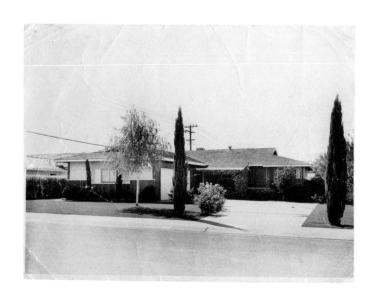

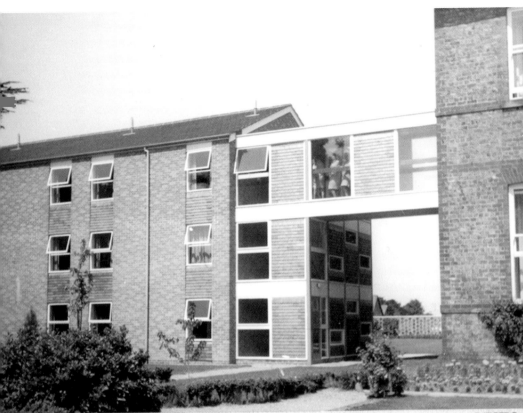

Franklin Hall, University College of West Mercia.

Left, the house at 1317 Ellesmere Ave., Los Angeles, where Gray and his wife lived from 1976 to 1983. Above, the women's residence at UCWM.

Maybe you think I've set my sights too low. Why not go big? Build an army. Seize a refinery. Be a warlord. Range the land extorting the locals. I don't know. Have you got the stomach for it? Have you got the right mental distortions? I'll bet you're basically still a nice middle class girl. Also, what I'm leaving isn't enough. And there's no stopping once you start on that road. You'd need a big haul quick, and you'd need a bigger haul pretty soon after. And how do you know somebody tougher hasn't got his eyes on the same thing? More guys. More guns. Better aim. Ex-SAS. That is not a direction I feel qualified to advise on. You're just as likely to get wiped out.
[STOP]

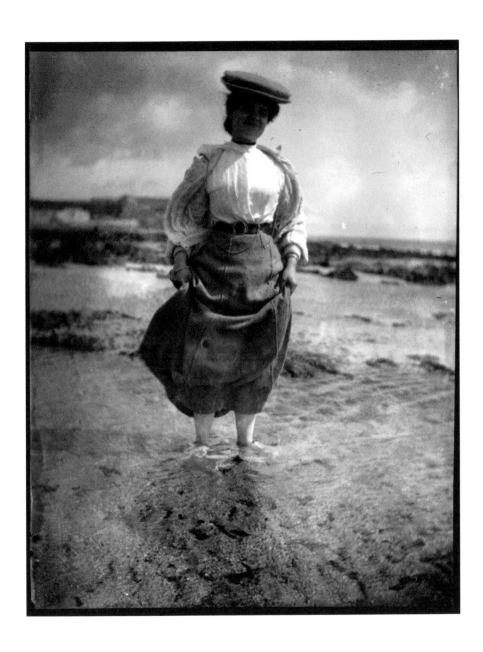

C.

1. A room of one's own.
2. The housing problem.
3. The enjoyment of poetry.
4. A beautiful building.
5. The future of railways.
6. The study of Natural History.
7. The subject you would like to study after leaving school.
8. How far should we do as others do?
9. Three books to keep always with you.
10. Either a great picture or a great musical composition.
11. The study of Stars.
12. Food and clothing a hundred years hence.

13. Life in some country in the past.
14. Motor cars.
15. Folk songs and folk dances.
16. The value of knowing foreign languages.
17. The weather.

26. Give yourself enough time to get set up. There will be ever such a lot to do and you can't delegate much until you know you can trust your lieutenants. It will be very exhausting until you have your systems in place. It will be very exhausting.

OPERATIONAL RATION PACKS
GENERAL PURPOSE (GP), COLD CLIMATE (CC) & HOT CLIMATE (HC)
RELIGIOUS VARIANTS, VEGETARIAN AND PATROL

Menus

A	B	C	D	E	F	G	S1	S2	S3	H1	H2	H3

Breakfast

| Hamburger & Beans | Corned Beef Hash | Sausage & Beans | Corned Beef Hash | Bacon & Beans | Beefburger & Beans | Meatballs & Pasta in Tomato Sauce | Meat Free Sausage & Beans | Meat Free Mini Burger & Beans | Meat Free Sausage & Beans | Meat Free Sausage & Beans | Meat Free Mini Burger & Beans | Meat Free Sausage & Beans |

Main Meal

| Soup Chicken Mushrooms & Pasta / Treacle Pudding | Soup Beef Stew & Dumplings / Chocolate Pudding in Chocolate Custard | Soup Lamb Stew with Potatoes / Treacle Pudding | Soup Pork Casserole / Fruit Dumplings & Custard | Soup Lancashire Hotpot / Fruit Dumplings & Custard Sauce | Soup Steak & Vegetables with Potato / Rice Pudding | Soup Chicken Stew with Dumplings / Chocolate Pudding in Chocolate Sauce | Soup Vegetable Tikka Masala / Treacle Pudding | Soup Vegetable Chilli / Chocolate Pudding in Chocolate Sauce | Soup Vegetable Casserole / Rice Pudding | Soup Chicken Casserole / Treacle Pudding | Soup Steak & Vegetables / Chocolate Pudding in Chocolate Sauce | Soup Lamb Stew / Rice Pudding |

Menus

V1	V2	V3	P1	P2	P3	P4	K1	K2	K3

Breakfast

| Non Meat Sausage & Beans | Non Meat Burger & Beans | Potato & Beans | Hot Cereal Start | Instant Oats & Apple Flakes | Hot Cereal Start | Instant Oats & Apple Flakes | Turkey Sausage & Beans | Burger & Beans | Sliced Salami in Tomato Sauce |

Main Meal

| Soup Vegetable Tikka Masala / Treacle Pudding | Soup Pasta Mushrooms & Sweetcorn / Chocolate Pudding in Chocolate Sauce | Soup Spicy Vegetable Rigatoni / Rice Pudding | Soup Potato and Beef with Herbs / Rice Pudding with Apple & Cinnamon | Soup Pasta and Carbonara / Chocolate Chip Pudding | Soup Chicken Balti / Apple with Custard | Soup Chicken with Noodles / Peach & Pineapple Pudding | Soup Beef Casserole with Dumplings / Chocolate Sponge | Soup Salami with Pasta in Tomato Sauce / Lemon Sponge & Lemon Sauce | Soup Lancashire Hotpot / Apple Strudel in Syrup |

Snack
Oatmeal Block
Instant Oat Cereal (CC only)
Fruit Biscuits
Brown Biscuits
Cheese Spread
Meat Pate
Chocolate
Boiled Sweets
Kendal Mintcake (HC only)

Drinks
Chocolate Drink, Beverage Whitener, Sugar, Tea, Coffee, Stock Drink and Orange or Lemon Drink (Both flavours issued with HC)

Sundries
Chewing Gum, Weatherproof Matches, Paper Tissues
Water Purification Tablets

27. Build a library of medical and agricultural texts and other reference material so you can deliver babies, perform basic operations and generally know how to do things. Forbid access to this library to anybody but your lieutenants. Your people must not be able to live without you. Your edge is going to be knowing how to do things. And being ready.

28. Be prepared for a variety of adverse environmental conditions. Radioactive contamination. Temperature fluctuations. Learn how to purify water in a radioactive situation.

29. What will you have to offer? Think about that. Maybe nobody else will be making shoes like your people. Maybe nobody's going to wipe you out because you're the only guys who know how to do sheet metal work.

Okay, Jones was nuts. And desperate, even though what's at stake for you is more serious. All I'm asking you to do is get a group of thirty people, or maybe more, I don't know really, it depends on how much land you've got. I'm tempted to say somewhere like northern Saskatchewan or Labrador but it may not be worth the time it'll take for all the legal ins and outs and emigrating, although you'll get a lot more land for your money over there. A lot more. I hear in California they can produce enough food for a hundred people on three acres. But that's permaculture. And it depends on what the climate's doing then, and soil fertility. You're going to also need enough land to blend in as if you weren't there. Which reminds me. Instead of pastures for cattle, think about foraging livestock like pigs and chickens. They're good in the woods. Anyway. Jones. Perfect. He went in under everybody's radar. He'd do the thing no one else had the bad taste to do. Then he'd stand there watching it all go like clockwork. Doing a little jig. By 1978 he was doing deals with the Russian embassy in Guyana. He was going to move the whole lot of them to Russia. He had a thousand people learning Russian. At the same time he was netting forty thousand a month in social security cheques from the US government. He was at it right from the beginning. He got accredited as a methodist minister but kept getting really basic doctrine wrong. He could never wrap his head around the Trinity, for one thing. He didn't really give a shit. Even then. He didn't believe the stuff. There's a lot you need to learn from Jones. No one has any allegiance stronger than their allegiance to you, personally. The figure you create.

Keep them scared. Keep them off balance. Keep them grateful. No independent little family units. No precious mother-daughter relationships. I'm sorry. This is not going to be some pleasant gathering of like-minded individuals in a rustic setting. You're going to have to make a tight little survival machine that'll last for as many generations as it takes. That's where Jones went wrong. He really was nuts. He took himself far too seriously. There're all kinds of analyses you could run on why Jonestown ran into the ground. Cults are tricky things to manage. You need a goal that is completely unattainable. At the same time you can't let anybody get disillusioned. If they're disillusioned you make it their fault. They've got to try harder. Quigley would say the Peoples Temple's instrument of expansion became institutionalized. Jones needed more people, more revenue, more political clout. He needed to devolve authority. He should have been remote by 1978. He should have been mythic. But his need to control everybody kept him in full view. They could all see him getting fat and scared. When it got to be too much leaving his cabin he'd make announcements all day on the PA system, slurring from the quaaludes. He should have fixed a simple doctrine so that people could internalize it instead of shifting his ground all the time. I mean in a sense he absolutely perfected group control because he led a thousand people to suicide but from your point of view that is not the outcome you're looking for. Plenty of other cults have done really well. They're not even called cults anymore. [STOP]
Er...
[STOP]

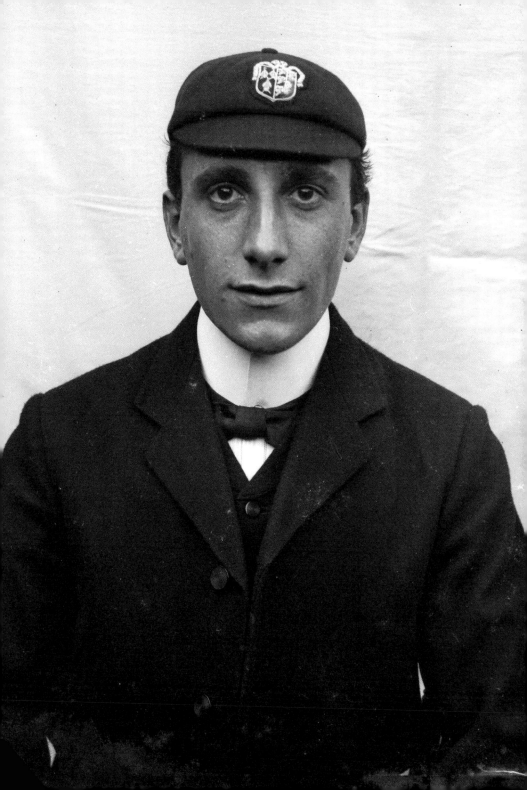

30. There will be lots of scrap metal around for tools, and knives. You can smelt metal. You make furnaces in the ground and burn charcoal and you can smelt metal. There's going to be plenty of metal around. You're going to need a book about making charcoal, though.

ADVISORY LEAFLET

No. 21

WOODPIGEON
SHOOTING

SOME PRACTICAL HINTS

31. Cutting. Sawing. Joining. Welding. Sharpening.
Pots. How are you going to mend pots?

I'll tell you what you are. Attila. You are Genghis Khan.
[STOP]

32. The point is to provide a self-sufficient sanctuary until external threats have abated sufficiently for people to move about freely. It's impossible to predict how long that will be. It may take months but more likely it will be years. You should prepare for it to take generations.

34. Don't set out to create a new civilization. That's asking too much. And anyway there may be no point if the conditions for human life have deteriorated beyond a certain level. Look at it more as a human time capsule that can survive the period where resources are being snatched by whoever can.

33. At the end of it all you should emerge as a force to be reckoned with if some kind of society starts to emerge again. If you choose to participate do so on your terms.

It is not true that I slept with all my students. I slept with two. Graduate students. Grown young women. They wanted me, I wanted them. Why didn't your mother leave, like you kept telling her she should? Because she wanted me, too. And I wanted her. This was a good civilization. How many civilizations do you know where you can do that? And where nineteen-year-olds can denounce their father and run away to Palm Desert to find themselves and not be located and made to return, much as one would like to do that. Much as it would have been well within one's rights and duties as a parent to do that. It was a good civilization but it let me down. They do that.
[STOP]

Appetite is the thing. Appetite is our undoing. It all depends on appetite. A billion people in China want cars now. That is not an appetite Hu Jintao's going to mess around with. A billion people in India want cars now. You have to wait such a long time for enough of your fellow grains of sand to have the same healthy appetites as you. Couldn't we just make do with spring water? Socrates and his boys had their city sketched out very quickly. It looked great. The class structure promoted fairness and efficiency. Everybody shared property. Laws were just and strictly enforced. They cultivated basic arts. Food was simple and wholesome. Barley loaves, vegetables, maybe some shellfish. Everybody was healthy and ardent. But hang on. One of them says, What about relish? They're going to need some tasty condiments aren't they? It's all looking a bit dull. Socrates sighs. They'd cracked it. In the book, you're on about page 17. Now they want relish. Relish means spices. Vinegar. Vinegar? How do you make vinegar? Do you know what's involved in making vinegar? Oil. Do you know what's involved in making oil? You need a whole class of people where that's all they do is make oil. Spices. Where are you going to get your hands on those? Relish means specialization of labour. Trade with foreign countries. Relish means expeditions, expansion, currency, subjugation, resource extraction, war. War! But these guys want relish. You've got to have relish. It could

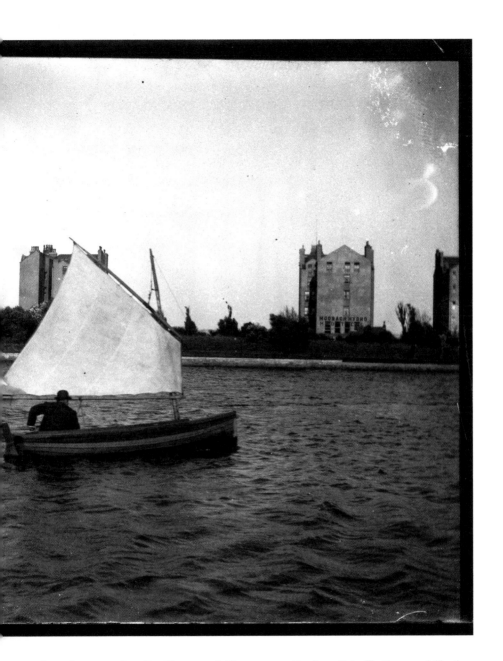

have been a calm city. Clear-eyed. Now it's going to be feverish and inflamed. They spend the next four hundred pages trying to create the ideal society allowing it an appetite for relish. That's our civilization. It let me down. It let me down. And here I am telling you to do this stuff. [STOP]

Gentleman's Relish. Right. God what's in this stuff? Right. Okay. Not much, actually. Salted anchovies. Comprising salt and anchovies. Butter. Salt. Rusk. Herbs. Spices. Gelsemium. No, it doesn't say gelsemium. I'm adding that bit.
[STOP]
You're supposed to spread it thinly on a piece of toast with unsalted butter but I don't have any toast here just now.
[STOP]
Ach! Jesus. No wonder they say unsalted butter.
[STOP]

35. Anyway it will take a
lot more than you and
the contents of your
brain to spark another
whole civilization.

I have to say, gelsemium is remarkably easy to come by on the internet. It's not even illegal. State flower of South Carolina, apparently. It causes paralysis, respiratory depression, giddiness. Ptosis. Ptosis is droopiness. Giddiness. That might be fun.
[STOP]

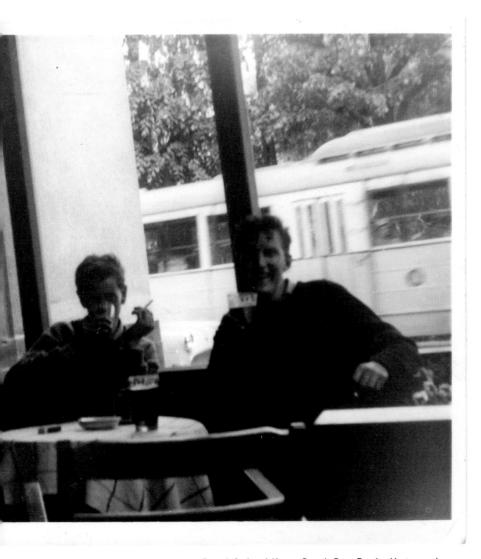

Gianni Motta's bar, Los Angeles, 1976. From left, Januk Kuntz, Gareth Gray, Barclay Horton and Vigo Eriksen. Photograph: Anstice Werner.

I was at the station once climbing up the steps and there were these boys ahead of me, they had a dog on a lead, one of those terriers. They were pulling him up the steps but he was having some kind of trouble. Then he shat. He parted company with the hugest stool. It looked like it hurt. It came tumbling down. They were just laughing and yanking the dog around. I pictured the dog packed with meat. Tins of cheap dog meat. Look at him eat. I thought then wouldn't it be great if children like this could be ganged into militias. Picked off by bigger groups of bigger boys. I was brought up a nice lad. Nice thoughts always tried to catch up with the nasty ones and shoulder them out of the way. Why not go, they're just kids who could use some feedback on caring for a dog? That's what you're seeing here, after all. Somewhere there is a little fire of love and hope maybe in a mother or a father and these boys can feel it sometimes on their backs. That's something we're conditioned to imagine. It's a vision we're conditioned to cherish. I don't feel that anymore. A sheep bleats for its slaughtered lamb for what? Couple of hours? A day? They are not worth anything. This is the raw material of civilization but we don't know what to do with it anymore. What are they going to do? Apprentice as pipe fitters?
[STOP]
The shutdown gene.
[STOP]

What about relish? What about relish? Can we have some relish, please? Why can't we have relish? There's nothing wrong with a bit of relish. It's just a bit of relish. Go on, give us relish. A bit of relish. Relish. Relish. Relish relish relish relish relish...
[STOP]